AN INTRODUCTION TO PIXEL LIGHT SENSORS FOR CAMERAS

Cover Figure: A Pixel Well. See Text For Explanation

CONTENTS

I. Introduction ... 3

II. The Pixel .. 5

III. Sensors ... 10

IV. The Bayer Sensor .. 11

V. The Foveon Sensor 13

VI. Summary and Conclusions, Part I 15

VII. Summary and Conclusions, Part II 18

VIII. Figure 1 .. 20

IX. Figure 2 .. 21

X. About the Author .. 22

XI. Publications ... 23

XII. Contact the Author 26

I. INTRODUCTION

Here is a list of the subjects I will discuss in this book.

1. What is a pixel?
2. How do pixels function?
3. How do pixels generate color?
4. What is a Bayer sensor?
5. What is a Foveon sensor?
6. Pixel size issues.
7. How many pixels for a sharp photo?
8. Pixel resolution issues.
9. Pixel back-up security.
10. Sensor size.

The pixel is the single most important component of the DSLR; no image, no photography. But, how many of us really know what a pixel is and how it functions?

While I discuss pixels from a photographer's view point, much of what I say is applicable to any pixel light sensor, such as your television, cell phone screen, or other optical devices.

This may be the first book you have read about pixels and sensors. Discussions on these subjects are often published in highly technical articles, which are too difficult for many of us to understand. And, not many lectures on pixels are presented at photography meetings.

In this book, **"AN INTRODUCTION TO PIXEL LIGHT SENSORS FOR CAMERAS"**, I hope to demystify the subject so that you will have a better understanding about how your camera produces a photograph.

The pixel sensor is the most advanced light detector in a long series of sensors that began almost 200 years ago when the permanent recording of a visual subject was achieved (the birth of photography).

This recording first occurred in 1821, when Niepce photographed a street scene in Paris, using light sensitive tar, and an exposure time of many hours or even days. Today, exposure times of 1/10,000 sec. and faster are not uncommon.

Only a short time ago, digital sensors were extremely expensive, about $10,000 for a military camera with

about 1-megapixel (mp) sensitivity. Now, multi-mp cameras are available for less than $100.

I can remember in 1996 when I purchased my first digital camera, a Canon Power Shot with 0.5-mp. I was quite pleased with most of the images I obtained for 4" x 6" prints, which compared quite favorably with prints made from 35-mm film.

II. THE PIXEL

You probably know the definition of the word pixel, but here it is again: "pix" stands for picture, and "el" for element, thus picture element.

Like film, millions of pixels are required to produce an image. In fact, the higher the pixel count the more the image will be resolved in terms of dots per inch (dpi).

But how many millions of pixels do you really need to make a high quality small-sized print? Studies have shown that only 5-6 megapixels are required, not the 50+ mp that are currently available. But, don't look for a high quality 5-6 mp camera; they are no longer available.

However, as more megapixels are crammed into today's sensors, a pixel's size is automatically reduced. Like film particles, small pixels are less sensitive to light than larger ones. This condition requires longer shutter speeds or larger apertures. These are not necessarily bad conditions, but some photos require just the opposite settings.

And, the reduced light insensitivity for small pixels can be largely mitigated by using ISO controls on your cameras, which digitally enhances a pixel's response to low light levels.

Pixels basically act as light collectors and counters. As a lighting source becomes more intense, a pixel fills up, like engorging a meal.

But, I don't think an individual pixel cavity must fill up completely before another pixel takes over; therefore, the filling is not sequential but communal.

However, the more pixels that do participate in collecting light, the more fully resolved an image will become. If some light remains uncollected, such as in a low pixel count detector, a photograph becomes "fuzzier" when its print size is increased.

But, how many megapixels are really required to improve the resolution for larger sized prints? Is 5-mp (as the literature states), or 20-mp resolution, required to produce sharp 8-by-10" prints?

To test this requirement for myself, I photographed the same subject with two cameras—one, a 10-mp point-and-shoot camera, and the other, an 18-mp DSLR.

I then compared the resolution of the 4-by-6" and 8-by-10" prints I made with each camera.

To my surprise, I did not observe what I expected: both 8-by-10" prints were nearly identical. Please see **Summary and Conclusion** for my explanation.

We seldom use all the pixels we have purchased—you may find an "advertised vs. actual" disclaimer hidden in the small print of your camera manual.

For example, if a scene is missing green subjects, the pixels responsible for detecting green will not be used. The same pixel loss can be expected for other colors missing in the scene. What about black and white

subjects with no colors? Perhaps no pixel deprivation occurs here?

Thus, at least for colored scenes, your 25-mp sensor could be reduced to a pixel count of much less than you paid for.

To a chemist like me, the principles behind how a pixel sensor converts light into an electrical signal are not too complicated. But, I certainly don't comprehend how these principles can be so successfully engineered into the wonderful pixel sensors we have today.

For an easily understandable analogy about what a pixel can accomplish, compare a roof-top solar panel to a pixel. Both devices collect light and convert it into electrical signals.

In **Figure 1,** and on the **Cover Page**, I show an unusual structure you probably don't recognize as a pixel. It is not a solid particle, like film, as you probably imagine it to be.

Rather, a pixel is a cavity, well, or bucket, the inside of which is coated with a semiconductor film, and the opening covered with a filter, called the **Bayer Filter.**

As I schematically show in **Figure 1**, red light is passing through a red **Bayer Filter** into the interior of the well, where it is trapped and counted as an electrical signal.

Millions of these structures occupy the surface of the sensor, often a thin silicon wafer. Thus, a pixel sensor is not a smooth surface, but resembles a pock-marked, moon-crater-like surface.

Pixel well coatings come in two common types: a CCD (charge-coupled device) or a CMOS (complimentary metal oxide semiconductor). Both varieties of these semiconductors accomplish the same task of converting light into electricity, which the camera records.

I won't go into the advantages of each coating (unless you contact me), other than the CMOS type is generally the favored variety, and is most likely what you will have in your camera.

However, a pixel can only measure the amount of light it collects. It has no way of determining the color of the light. As such, the sensor can only record in monochrome. Another color-producing process, which I'll discuss later, is required.

III. Sensors

A light sensor is a device that detects or measures light, and records, indicates, or otherwise responds to it. The pixel representation I show in **Figure 1** is only one of the millions found on a sensor's surface.

Todays' pixel sensors come in at least 5 sizes: (1) the "full frame", about 1 sq. inch (36 x 24 mm), (2) the APS-C (22 x 16 mm), (3) the smaller 4/3 sensor, (4) the even smaller cell phone detector, about ½ the size of your smallest finger nail, and (5) the **Foveon Senso**r, which I will describe later.

However, the term, "full frame sensor" is a misnomer; there is no upper limit to the size of any pixel sensor, such as those used in medium and large format cameras, and in astronomy telescopes, which may reach many square meters in surface area.

A pixel sensor's surface area is the key factor for how much light the sensor can detect, and thus its effectiveness at detecting far-away subjects. In many cases this size dependency supersedes the number of megapixels a detector contains. But, larger sensors are more expensive.

Camera manufacturers obviously want to comply with the public's demand for smaller and less expensive cameras. A larger sensor will certainly take up more space and weight, and at a higher cost.

IV. THE BAYER SENSOR

The pixel sensor in common use today is called the **Bayer Sensor**. The word **Bayer** refers to a filter that covers each of the pixel wells.

The purpose of the **Filter** is to create the colors you see in your photographs. In **Figure 1,** and on the **Cover**, I show a schematic representation of this arrangement, where a red **Bayer Filter** that resides on top of a pixel well, allows only red light to pass into the well.

However, other colors are present in most scenes. Thus, the **Bayer Filter** I show in **Figure 2 A** consists of the primary colors red, green, and blue, in alternating rows of patterns, with a different color residing on the top of each pixel well.

The entire configuration--well, semiconductor coating, and filter--is called the **Bayer Sensor.**

And, as you can see in the **Figure 2 A**, there are more green patterns than red or blue. This is because for most scenes, green is the predominant color; thus, more green-sensitive pixels are needed.

In **Figure 2 B,** I show two consecutive pixel well layers on which a **Bayer Filter** is placed. Each pixel has a different red, green, or blue filter covering it, allowing a different color to pass into the well. At the edges of each pixel well are lenses that help focus strayed light back into the wells.

Bayer Filters work like other filters you may have used for your photography; they transmit only their own colors, and reflect others; thus, a red filter passes red light, but blocks blue and green light. A blue filter transmits blue, but reflects green and red.

The process for calculating colors requires the input from 4 adjacent pixels in a complicated process called demosaicing, which I won't review here.

That pixel sensors produce such accurate color representations is astounding when you consider for red,

green, and blue light, the primary colors, there are about 17 million possible color tones.

Thus, to record every possible color tone, you would need at least a 17-mp camera sensor. But, since 4 pixel cavities are needed to produce a single color, a 68-mp camera would be required.

Luckily, you won't view many scenes that contain all of the possible 17 million color tones, which you probably couldn't differentiate between anyway.

V. THE FOVEON SENSOR

There's another digital photo sensor on the market that I must tell you about—The Foveon Sensor.

Foveon is an interesting name for a sensor, because it's probably derived from the word fovea--a portion of the human eye at the center of the retina that permits 100% visual acuity.

Currently, the **Foveon Sensor** is a product of only one camera manufacturer, the Sigma Corporation.

The **Sigma X3 Foveon Sensor** consists of 3 stacked layers of CMOS pixel wells on silicon chips, each layer measuring the intensity of the light that passes through it.

In theory, the **Foveon Sensor** has the potential for size enhancement, because only one dimension, the height, is increased by adding more layers. The base layer dimensions remain unchanged.

Whether this geometry modification could be used in all DSLRs without cost and size implications has yet to be determined. The current **X3 Foveon Sensor** is already more sensitive to light than the **Bayer Sensor**; but is it more sensitive by a factor of three (the number of stacks)?

Finally, the **Foveon Sensor** detects colors by measuring the penetration depths of different wavelengths of light (colors) into the three stacked layers. Blue penetrates the deepest because it is the most energetic.

The Sigma Corporation has great hopes for the success of this innovative pixel sensor, which might conveniently increase the light detection area over that found in many non-Sigma DSLRs.

VI. SUMMARY AND CONCLUSIONS, Part I

At this point, I hope I have described to your satisfaction the topics I listed in **Introduction.**

As an additional aid to achieving this goal, I have divided **Summary And Conclusions** into two sections, **Part I and Part II.**

This division gives you two different approaches for understanding more completely my pixel sensor discussions.

In **Part I**, I propose the megapixel packing frenzy you observe in todays' DSLRs (you can barely find a camera that has less than 20-mp) is giving many photographers the wrong message: the quality of your images depends entirely on the mp-count of the sensor.

However, I know you are aware that it takes much more than a high resolution sensor to produce a sharp image, such as the quality of your lens.

Everything else being equal, a sensor's resolution capability is the bottom line, but to a different level than

you might expect. For example, I showed in my earlier test results, a 10-mp sensor can provide a high quality 8-by-10" print.

Camera manufacturers will probably never discuss this result; they continually court the "megapixel hype": you need more pixels in reserve to generate that ceiling-sized print you someday will produce.

I coin this philosophy as "Pixel Back-up Security" (PBS).

But, many photographers don't require PBS; the majority of their photos are taken with point-and -shoot cameras and cell phones, where high resolution is not observable on the tiny screens these devices possess. They seldom produce storable prints from these images anyway.

Earlier in **Pixels,** I stated my opinion that every image you produce is as fully resolved as the current megapixel level will allow.

Even cell phone images, at only about 12-mp resolution, appear well-resolved. But, blow up that image, and the resolution degrades. Larger resolution pixel sensors, in excess of 20-mp, will result in less photo-degradation when the print is enlarged.

However, my experimentation on this subject (see **Pixel**s) did not produce the results I expected to achieve: both 8" x 10" prints from 10- and 18-mp sensors were nearly identical. Why?

I offer the following explanation: (1) I probably needed a larger mp resolution difference than just 10 to 18-mp, and (2) I don't need a large mp sensor to make a good quality 8" x 10" print: 10-mp is sufficient.

But, if you're "hooked", probably like me, on having as many megapixels as you can purchase, I don't believe an excess is necessarily a bad idea. I, too, don't want to miss out on that once-in-a-lifetime, large sized print I might produce in the future.

I now conclude with a major topic I wish to address in this book: **Sensor Size.** Earlier I discussed that sensor size is more influential on the visual quality of a digital image than on the pixel count the sensor contains.

But, I think sensor size enlargement has reached a steady state in its development where little research is probably taking place, except, perhaps, for the **Foveon Sensor**.

I don't understand why camera manufacturers haven't attacked this problem more vigorously. They continue to incorporate very small sensors, about 1 sq. in., or less, into their DSLRs, and even inaccurately call it "full frame". Certainly, they must realize the advantages provided by larger sensors in medium and large format cameras.

I suggest this dilemma is probably based on economic considerations. Larger sensors require more infrastructure than smaller ones, at the expense of higher cost and size, which the public wants to continually minimize.

Finally, as I described earlier, the Sigma Corporation is making attempts to resolve these issues in their stacked-layer **Foveon Sensor**, which shows some promise for success.

VII. Summary And Conclusions, Part II

In this section, I offer a few recommendations you might consider when you are shopping for a new DSLR, based on its pixel sensor specifications.

1. Buy the largest sized pixel sensor available for your camera, or consider switching to, or renting, a medium or large format camera.

2. You cannot have too many megapixels. Having more provides higher resolution, but they are smaller.

3. Smaller pixels are less sensitive to light than larger pixels. Use the camera's ISO control to provide faster shutter speeds or wider apertures.

4. You may not need all megapixels you are sold, but you don't have much of a a choice. Check the print sizes you commonly make. For good quality prints under 8" x 10", you only need a 10-mp sensor (see my print size test results).

5. You will not observe any resolution improvement results with multi-megapixel sensors if you only store your images on small prints, or on your computer and cell phone image screens.

6. Follow Sigma Corporation's progress in improving their **Foveon Sensor.** You may want to buy a Sigma camera some day.

VIII. FIGURE 1

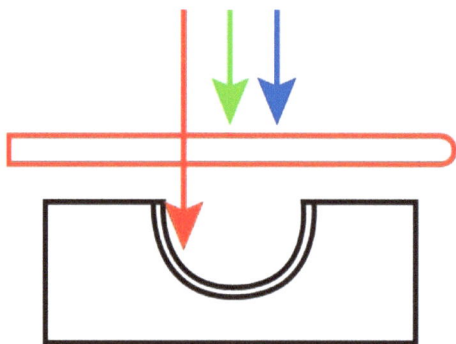

A Single Pixel Well Receiving Red Light Passed Through A Red Bayer Filter

IX. FIGURE 2

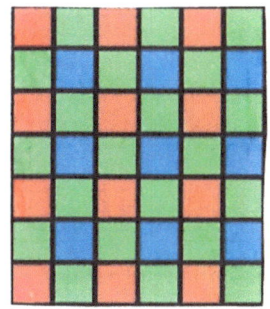
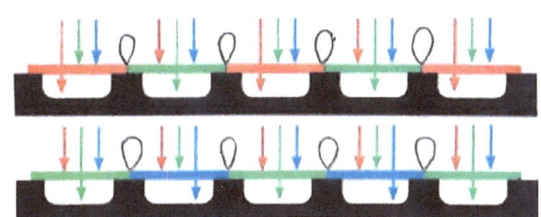

2 A--The Bayer Pattern Filter

2 B—Covered Pixel Wells And Lenses

X. ABOUT THE AUTHOR

Bob Rewick is a professional photographer, a teacher, and a research physical-inorganic chemist, surface scientist, and spectroscopist. He worked at SRI International, Menlo Park, CA, for 32 years, and 3D Technology Labs for 8 years, where he specialized in the optical properties of materials, such as semiconductors and up-converting phosphors.

Bob began his photography career in about 1985 by taking many classes, workshops, and seminars from well-known photographers, and at local colleges. He has belonged to 3 camera clubs in the Bay Area, and currently to **Friday Foto Fanatics** in Campbell, CA.

He has displayed his work at several San Francisco Bay Area gallery locations, including Stanford University, Palo Alto, CA, and the Coyote Point Museum, San Mateo, CA, and others.

Bob has travelled extensively around world and the U.S., He serves as a photography judge, a teacher and a lecturer on a wide variety of photography subjects,

including most of the books and articles found in **Publications.**

Bob, and his wife Joy, who is also a photographer, are co-owners of "Photo Expressions", a business concerned with teaching the "art" of photography, and learning how to "see". He has a preliminary website (Google the names **Joy and Bob Rewick**), where some of his very early work can be seen. A more current website is under development.

XI. PUBLICATIONS

Bob has written the following articles, and published most of them in National Journals, Amazon KDP Books, Createspace.com, and Focal Press Photography Blogs.

1. "Discover The Joy Of Close-Up Photography".

2. "Creative Backlighting For Transmitted Light Photography".

3. "Soap-Scapes": "How To Photograph Soap Film Interference Patterns", Part I: "Introduction And Background".

4. "Soap-Scapes: How to Photograph Soap Film Color Interference Patterns", Part II: "Improve Your Success Rate".

5. "Soap-Scapes: How To Photograph Soap Film Color Interference Patterns", Part III: " A More In–Depth Discussion".

6. Soap-Scapes: How To Photograph Soap Film Interference Patterns", Part IV.

7. "Expand Your Photographic Horizons: Learn To "See, Not Look", Three Exercises To Sharpen Your Skills".

8. "Crystal-Scapes: Unique Colors And Patterns You Can Photograph through A Microscope".

9. "How To Become An Artist With Your Camera: Principles, Techniques, and Exercises To Sharpen Your Skills", Vol. 1.

10. "How To Become An Artist With Your Camera: Principles, Techniques, And Exercises To Sharpen Your Skills", Vol. 2.

11. "How To Compose A Photograph", Vol. 1.

12. "How To Compose A Photograph", Vol. 2.

13. "How To Photograph Remote Subjects Using A Fiber-Optics Camera".

14. "The Art Of Judging".

15. "How To Achieve Color Accuracy In Your Photographs By Using Custom White Balancing".

16. "Transmitted Light Photography, The Lost Art Of Backlighting", Vol. 1.

17. "Transmitted Light Photography, The Lost Art Of Backlighting", Vol. 2.

18. "The Basics Of Photography; Light, Color, Seeing, And Composition-- Includes Exercises And A field Guide".

19. "Maximum Depth Of Field: Removing The Guesswork".

20. "How To Design Abstract Macro Photographs Of Feathers".

21. "Pre-Fogging: A Technique To Enhance Shadow Contrast".

22. "The Magic Of Pinhole Photography".

23. "Crab Spiders—Fascinating Little Photograph Subjects".

24. "Photo Microscopy For Beginners".

25. "A Fancy For Feathers".

26. "A Tool For Learning The Color Zone System".

27. "A Photo Studio In A Box".

28. "The Art Of Still-Life Photography".

XII. CONTACT THE AUTHOR

For questions or comments about this book, or on any of Bob's other articles and books (see **Publications**), please contact him at: brewick@earthlink.net.

www.ingramcontent.com/pod-product-compliance
Lightning Source LLC
Chambersburg PA
CBHW050429180526
45159CB00005B/2461